I AM ILL WITH HOPE

I AM ILL WITH HOPE

poems & sketches by Gommie

Salamander Street

First published in 2022 by Salamander Street Ltd.
(info@salamanderstreet.com)

I Am Ill With Hope © Gommie, 2022

ISBN: 9781914228575

10 9 8 7 6 5 4 3 2 1

'Poem' means to create
So I write 'poem' above what you say
Because your words help me see
That you have created me.

INTRODUCTION

In the wake of the 2016 Brexit referendum all I felt around me was division. The towns and the cities of the UK were painfully disconnected. The graduates and the workers were full of spite for each other. Divisions were no longer beneath the surface. Something quite potent and horrible had been released.

In 2018, I was at the fag end of a spectacularly nondescript acting career. A few months of the year on regional tours, a few awful television appearances, and the rest of the time I scraped by in London, barely able to pay rent. That's an understatement – I'll rephrase – I was point-blank unable to pay rent.

I had always written poetry and had always made art. I began putting snippets of my poems online, presenting them in a palatable way for Instagram. This led to a small following and a very small amount of income.

I didn't really know it at the time, but I was also suffering quite acutely from depression. I used art and poetry as a means of coping. My own mental state and the country's disjointed atmosphere seemed intertwined. I hated listening to the news but was obsessed with the news. I felt shame and confusion, and disgust for those in Westminster.

I channelled these feelings into my work. In February 2019, my art made it into The Other Art Fair. I was chosen to be part of Loyle Carner's album launch for *Waving Not Drowning*, exhibiting alongside Damien Hirst and Loyle's incredibly talented mother. And what's more, for the first time in my life, I had some profits.

I decided not to pay back into the rent trap.

I had no career, no partner, no children, no real place to live other than friends' sofas and spare rooms. I had nothing but the slightest suggestion that I could write poetry and make it pretty.

I set up a GoFundMe page and created a project that would see me walk around the coast of England and Wales in 365 days, with nothing but a tent, a few basic supplies and my pens. I would go from place to place, using a map to navigate each area and write poems based on my conversations with those I felt disconnected from on that same map. The result would be an artwork. I would sketch and document what I saw in my Moleskine diaries.

I would walk the coast in search of hope. My mantra became 'I am ill with hope'.

I began in Dover and walked north. Ramsgate, Whitstable, Faversham, Sheerness, Pitsea, Southend, Basildon, Ipswich, Felixstowe, Lowestoft, Cleethorpes, Grimsby, Hull, Spurn Point, Bridlington, Scarborough, Middlesbrough, Sunderland, across Hadrian's wall, Bowness-on-Solway, Carlisle, Workington, Whitehaven, Barrow, Lancaster, Blackpool, Preston, Liverpool, Flint, Rhyl. I caught buses when I needed to. I camped, wild-camped, stayed in terrible hotels, stayed in nice hotels. I rambled. I was lost. But I was lost with a purpose. To make poems outside of myself. At one point someone invited me to France for three days and I took them up on their offer. This helped me understand our perfidious Albion even more. In fact, it was in France I learned that particular phrase 'perfidious Albion'. Plus, it was nice to get away.

Nine months in, with countless artworks, maps and illustrations completed, I was picked up by Messums Gallery in Cork Street, London. They exhibited some of my maps, adorned with people's words and scribbles. I had also started performing my poems alongside the hanging maps. I entered The Other Art Fair again, this time picking up the Soho House Newcomer award, presented by the art historian and curator Kate Bryan. Everything was unfolding in a most surprising way. I was a professional poet. Selling my poems as artworks. Travelling. Working on my mental health. Mining for hope in hard times.

Then Covid struck.

Suddenly, I was in North Wales with a world going into lockdown. I retreated to London, once again relying on the kindness of my friends. Back to the sofa and spare room scenario. I, along with the rest of the country, had lost my flow.

As the lockdowns came and went, and time became sludge, I realised my project had to be abandoned. I sensed that to freely ramble the way I had in 2019 was no longer possible. Perhaps it was, but in truth, I had just been through a pandemic and was scared.

But I remained ill with hope.

I may have lost a project, but I had gained a method. I knew how to make my poems. But I couldn't keep falling back on friends' sofas. The first lockdown all but ruined one friendship. How many more could I afford?

I had sold enough poetry to build up a small nest egg. Enough to answer 'yes' when someone suggested I buy an old, beat-up rusty pink narrow boat.

It was a rash and slightly dangerous decision. However, my next chapter had begun.

The book you hold now is some of the illustrations and poems I have made since 2019. The colourful maps are somewhere else. On peoples' walls maybe, or folded up in the back of some dusty cupboard in Scarborough. The book you hold now is the places I went and the voices I heard. The book you hold now is the lockdowns and the small moments of peace I found with my pen during government-sanctioned isolation. The book you hold now is my first six months on the water.

I have been on this boat for over a year now. It's not without its problems. It's idyllic one moment and awful the next. It's constant work. I am following an ancient aquatic track that is both daunting and magical. I am still writing, I am still fighting my demons, and most importantly I am still making poetry. I am still, ill with hope.

Gommie, July 2022

CONTENTS

POEM

the
last
time
you
 held
me
 was
my

favorite

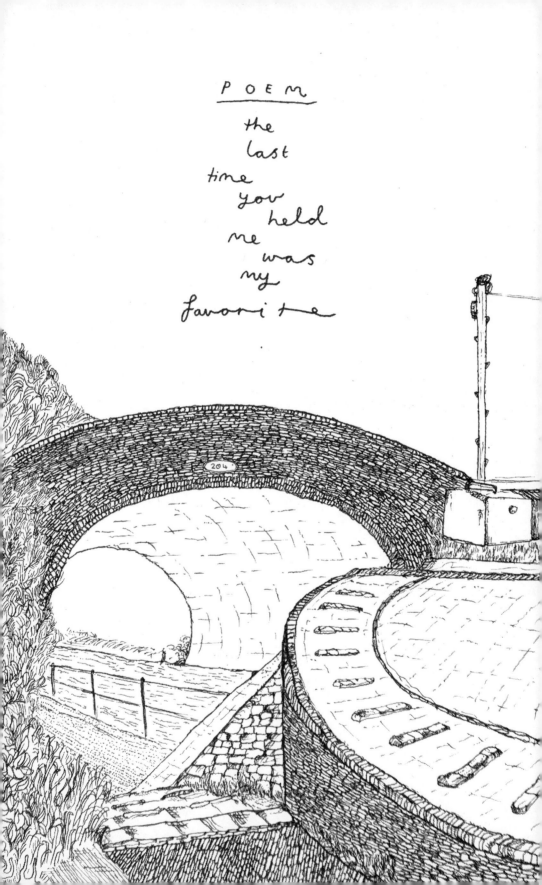

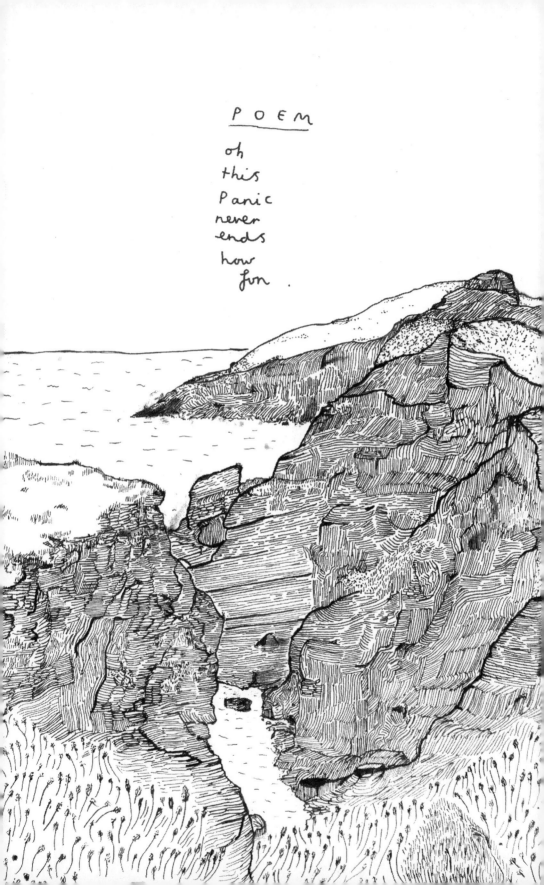

POEM

oh
this
Panic
never
ends
how
fun .

POEM

I woke up
With nothing
And I still
Felt
Love.

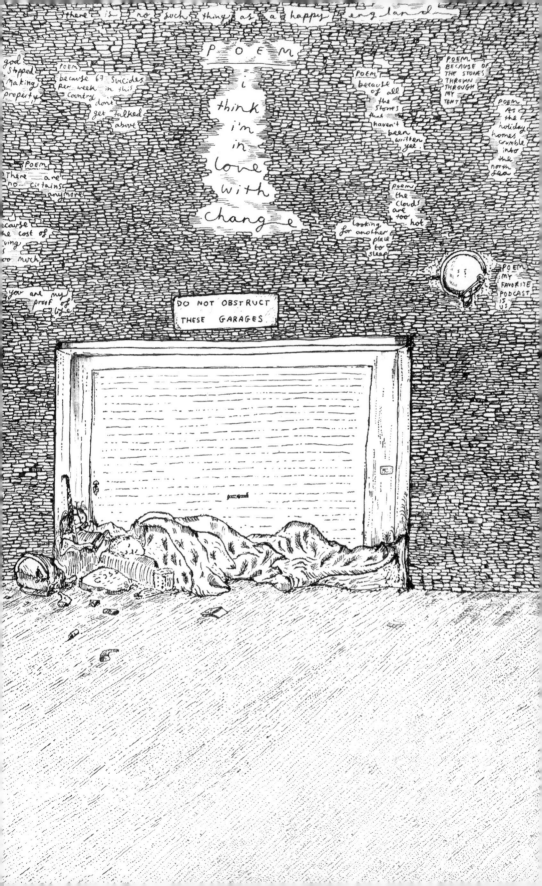

POEM

i believe love
is a
fluorescent
inevitability that
knows everything
except how to end

I KNOW YOU ARE LONELY

I know you are lonely.
And hurt.
Your heart has been broken
And you stand in front of the dry leaves
And say you match them.
You don't.
You are the pink and the blue and the red
All living next to each other
With no one dominant colour.
You are what makes my pen move.
You hug puppies
The same way I wish I could write poetry.
You champion those without a voice.
You hide my face with your kindness.

I know you are lonely.
And hurt.
You are just like me.
I am the left foot of Philip Guston.
You are the right foot of Agnes Martin.
You are Judy Chicago's purple plate.
Your thoughts wrap around words as snug as Christo
 and Jeanne-Claude.
Believe me, equilibrium doesn't exist without the U-Turns.
So I celebrate you.
In Procida.
Under Branch Hill Pond.
In the Louvre
Drawing pictures of tourists.
Stripped bare with Giacobetti
And using the humble perspective of time
As an interior decorator that
Hangs all good things to come.

I know you are lonely.
And hurt.
You are just like me.
But I also know you love dolphins
And believe that every romance is an essential journey.
You pick Renoir's flowers
And I know you would never, never, take any of the
 moments that hurt back.

No matter how much you miss them,
You're still here.

So sleep with the ravens.
Be lost in illumination.
Art is our phenomenon.
And remember it is falling down these disguised pits
That makes life
So
Damn
Magnificent.

You uplift me.
You make me want to build a ship,
Sit on a long table with you and
Eat pancakes on your birthday.
Understand Italian Baroque more.
Walk down the catwalk with Kimono.
Go on a tree adventure with Hockney.
Let him whip me.
I know exactly what it is you make me want to be.
You make me want to be.

I know you are lonely.
And hurt.
You are just like me.

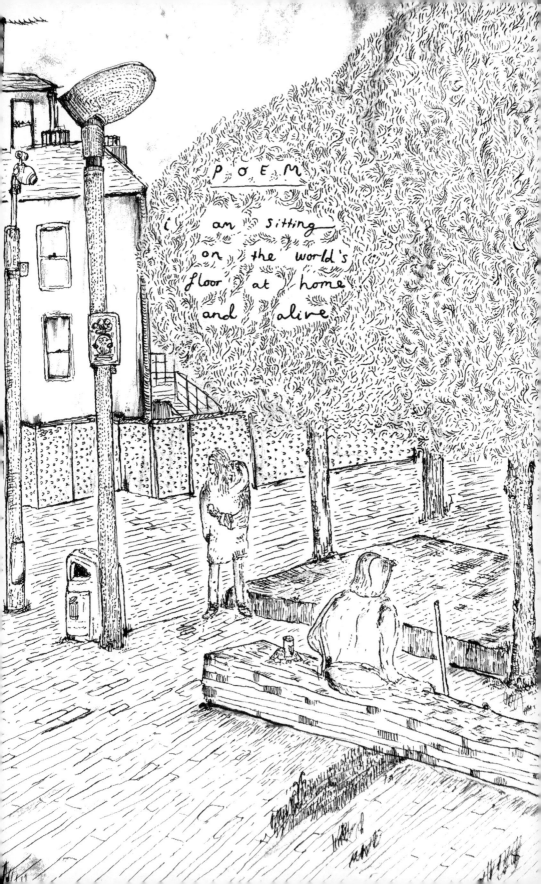

P O E M

i am sitting
on the world's
floor at home
and alive

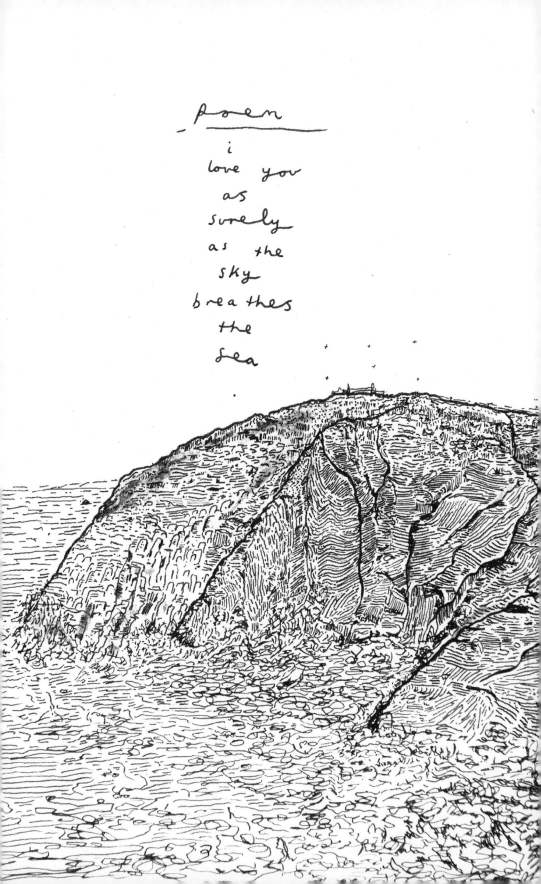

poem

i
love you
as
surely
as the
sky
breathes
the
sea

POEM

When you get low, so low
There is 26 metres of dirt
Above you
And you cannot see
Or feel
Or hear a sound,
I will dig a tunnel toward you.
I will sing for you.
I will be your Piano Underground.

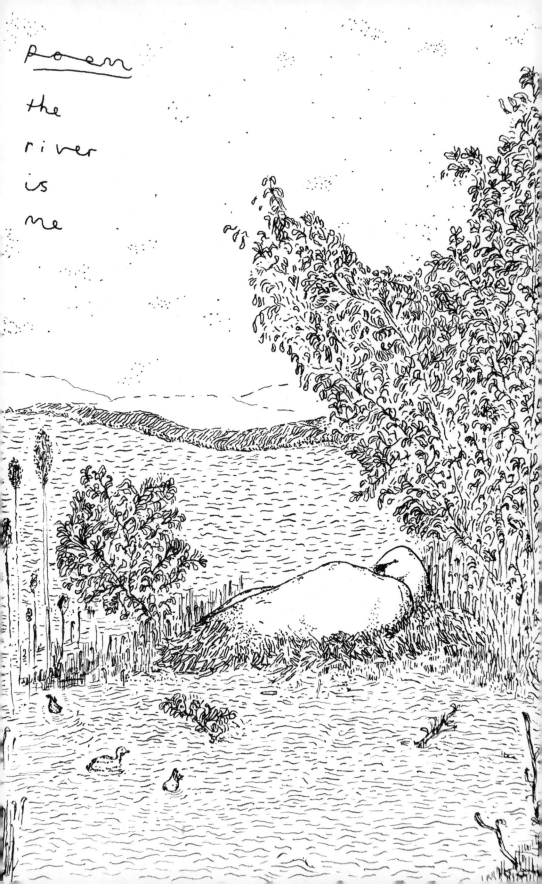

Poem

the

river

is

me

poem

all i

 h ear

 is the

 dist an ce

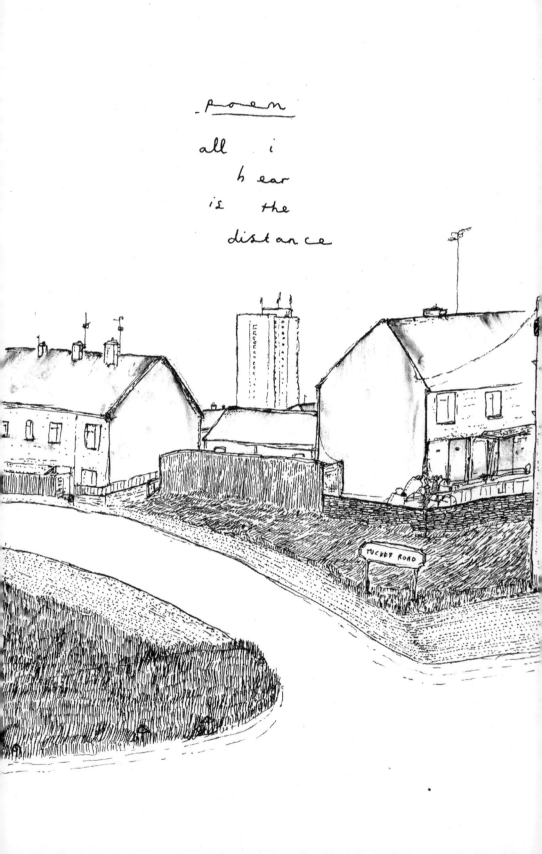

I MUST REMEMBER TO DREAM

I must remember to dream.
It wouldn't be a dream if I knew how to do it.
It wouldn't be a dream if it was easy.
It wouldn't be a dream if it didn't scare me.
Or make my palms sweaty, or stalk my sleep.

It wouldn't be a dream if it didn't move me.
It wouldn't be a dream if everyone understood it.
It wouldn't be a dream if no one got upset
About it.
Or annoyed about it.
Or asked no questions at all.

It wouldn't be a dream if it were done quickly.
It wouldn't be a dream if it were done smooth.
It wouldn't be a dream if it didn't fail
500,000 times along the way.
Or go upside down.

It wouldn't be a dream if it just
Gave up as soon as it starts to get weird.

Dreams don't go straight from one to thirty-three
Dreams don't need to know why they are dreams
Dreams don't need to feel comfy.
Dreams don't need an MRI scan
To prove they are not crazy.
Dreams are not from the head.
Dreams live in the drumming blood.
Dreams are a map.
Dreams are a story.
Dreams are a musical house
That sweeps up torture.
Dreams are in love with the alphabet
And in love with the mountains.
Dreams are disgusted by your artwork.

Dreams are the names of flowers.
Dreams repair the past
And eat the mulberries
And umbrella the piss
And invest in a compass.

Dreams don't want to do anything else
Because they know they can only do that.

Dreams are the salvation of talking.
Dreams are quiet.
Dreams know how to shut me up.

It wouldn't be a dream if it didn't
Beat me over and over again.

The chaos doesn't get less
But also what refuses to get less is my dream.

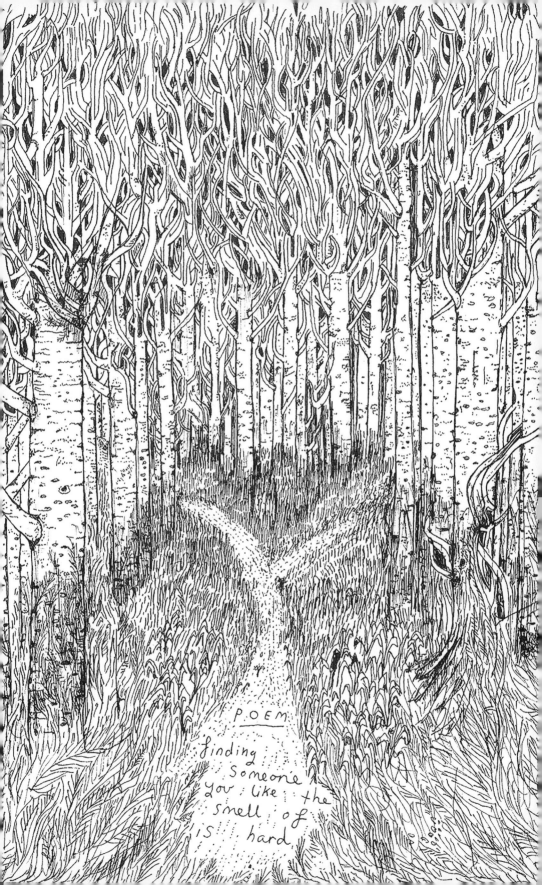

POEM

finding
someone
you like the
smell of
is hard.

POEM

the idea of
solitary confinement
scares the shit out
of me unless
it's with
you.

POEM

It is my opinion
That there is an
Invisible string
That lives between
Our chests
That is so tight
(And invisible)
That when your breath
Touches it
I can hear the string go
'Ping'
And I can feel the string
Quietly vibrating.

P oen

if we were

 here together

 we wouldn't fall out

i would draw the long pier

 and you

 would

 write

 about

 the

 blue

house.

i would draw a resonable picture

of a boat and you would pick

a strawberry and call it

 inno cent

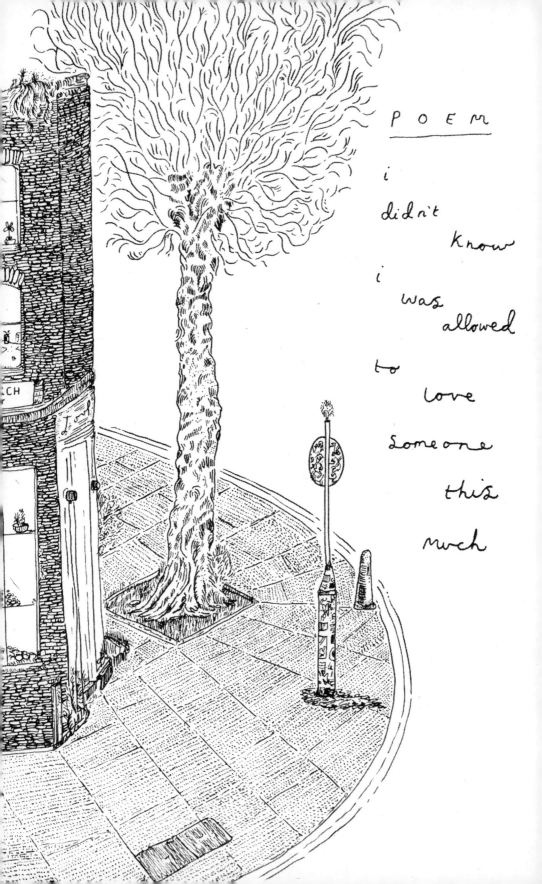

POEM

i

didn't

know

i

was

allowed

to

love

someone

this

much

POEM

Isolated
As
We
May be
We are still
In the world.

P O E M

i don't "miss you"
but i miss you
　　　i don't "love you"
but i love you
　　and your heart is not "good"
but your heart
　is
really
really
good

POEM

You are beautiful and
all my creative ideas
are stolen from you.

EXCUSE ME, BUT I WOULD REALLY APPRECIATE IT IF YOU COULD BE THE LOVE OF MY LIFE PLEASE?

Dedicated to Liv from Cardigan

That's called surviving, this is called living.
What time are you getting here tomorrow?
I have all manner of things to prepare –
The opera of the sea, the birdsong of the chippy.

The buses ain't regular, but the slow pace
Keeps the hills magic. I can't believe it's my
Birthday next week. Fifty. Years. Alive.

All I want is a thirty-pound bracelet and a bit of love.

I'll check the times for ya.
I'm excited, but also a little nervous.
We've all changed so much.
It's a different world now.
We all need to protect each other.

My heart is big and my skin is thin and the world is
scary.

Anyway, I'll see you when you arrive.

I'll wait at the bus stop for ya.

I
LOVE YOU
AS
SURELY AS
I LOATHE THE
CONSERVATIVE
PARTY

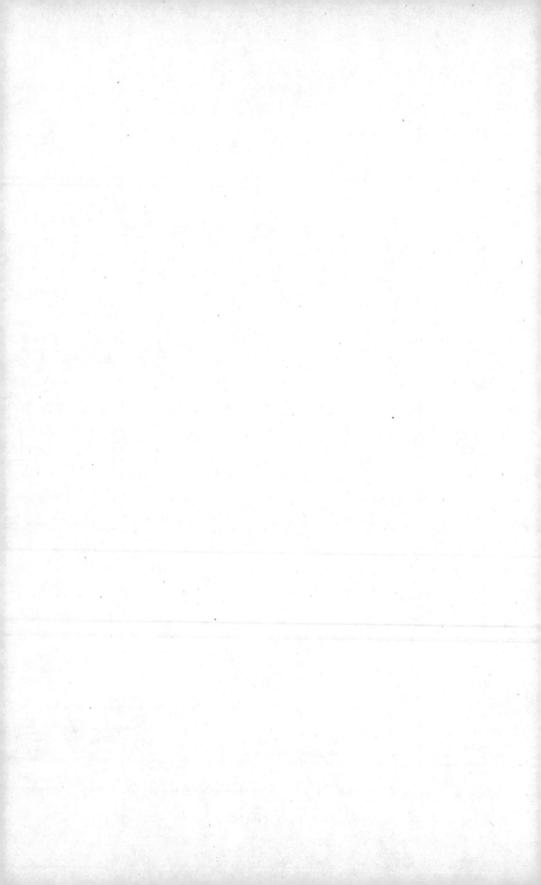

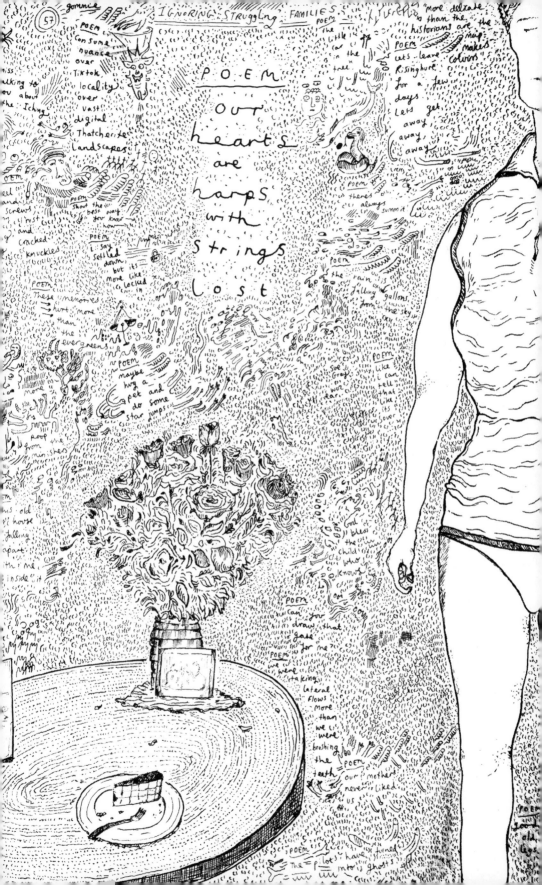

LET'S ALL RUN AWAY TO
WHERE EVERYONE COUNTS

Let's all run away to where everyone counts.
Let's all go to Holton Social club on holiday.
Let's all switch dreams to Barrow-in-Furness
And change trains at Wolverhampton
And hold hands in the market stall
And admit to all the obvious things we
Pretend we don't know but do know,
Like how scary all this is.

I spoke to Ellen.
She says there is not enough time
To do the things she knows she should.
I spoke to Babak.
He says he thinks he's losing his memory.
I spoke to Annie.
She says the country is a gobshite and a creep.

What if we are all just so incredibly lonely,
It's now impossible to talk honestly?

DM me your fears for the future.
Wave at me.
Please.
Give me a little attention.

Lucy told me the smell of the till in the Morrisons
Reminds her of her mum.
Beryl don't care who you are,
You need a purpose to get up in the morning.
Jacob needs to talk to the police
About his brother.
Alexander says this is clearly a case of
Judicial murder.
Shakya will take any cell except cell four.
Laurence listens to a podcast
On prehistory
While Natalie walks under
The M6 viaduct with me,
Her wig is pinching and she leaves a trail of
Clouds behind her feet as she walks.
She says her dreams are limping.

Peter always has these white jeans on
And he never has the flies done up.
It's off-putting.

It's been over six months of walking around
This country
And I note
Fifty-two hundred hills
All of which
Have wrung dry
Exhausted from your fears and mine.
Jules can't stand to see anyone
Struggle during the pub quiz
So she mouths the answers into the air.
1612.
Jacob's ladder.
The Moomins.
Frank still bunks the train from work at sixty-six.
Emma has fireworks instead of eyelids.
Mike says
Blackburn makes Preston look cosmopolitan
And I still don't know what a protestant is.

What if we are all just so incredibly lonely,
It's now impossible to talk honestly?

DM me your fears for the future.
Wave at me.
Please.
Give me a little attention.

The fraction of the life you are capable
Of living does not come from
Answering my questions
But it's nice to know
We're all freaking out in unison.

I'm scared.
I'm scared through and through.
I'm scared I'm no good.
I'm scared my face
Will always look this way.
I'm scared to eat more than
One mouthful.
I'm scared the country
Is not just divided into two,
It's divided into 10,449
Which is the amount of parishes
There are in England.

I'm scared I will never find a boyfriend.
I'm scared I will never get married.
I'm scared I will never
Make my parents happy.
I'm scared of IVF.
I'm scared of Greggs.
I'm scared of piles cream,
Dementia,
Fern trees and cancer.
I'm scared North End
Will never make it into the Prem.
I'm scared my life is one long
Never ending
Jez related
Peep Show meme.
I'm scared to open my eyes and let you in.
I'm scared
Because
I have never worked so hard
And
Never had
So little.

I'm scared. Properly.

What if we are all just so incredibly lonely,
It's now impossible to talk honestly?

DM me your fears for the future.
Wave at me.
Please.
Give me a little attention.

No matter what happens,
I do not regret meeting you.
You are the one I enjoy.
You have changed my life
(Of that there is little doubt)
So let's all run away to where everyone counts.

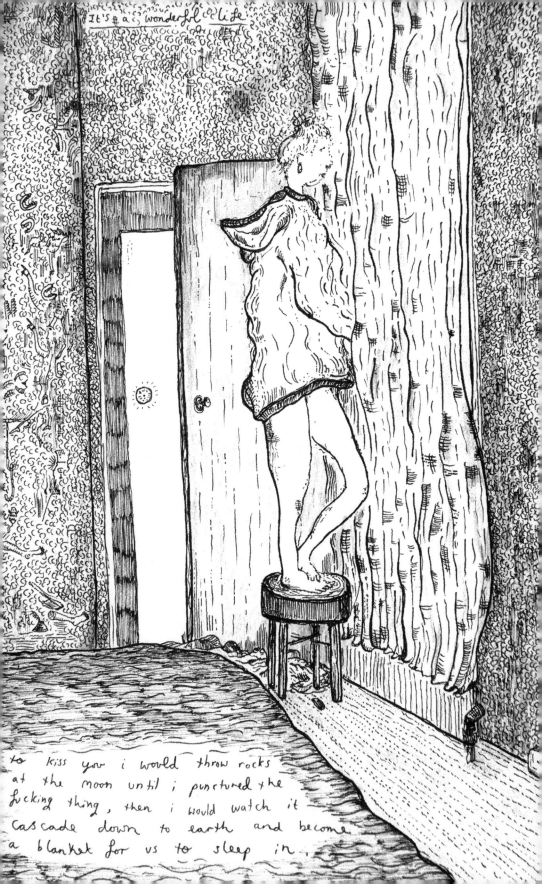

It's a wonderful life

to kiss you i would throw rocks
at the moon until ; punctured the
fucking thing, then i would watch it
cascade down to earth and become
a blanket for vs to sleep in.

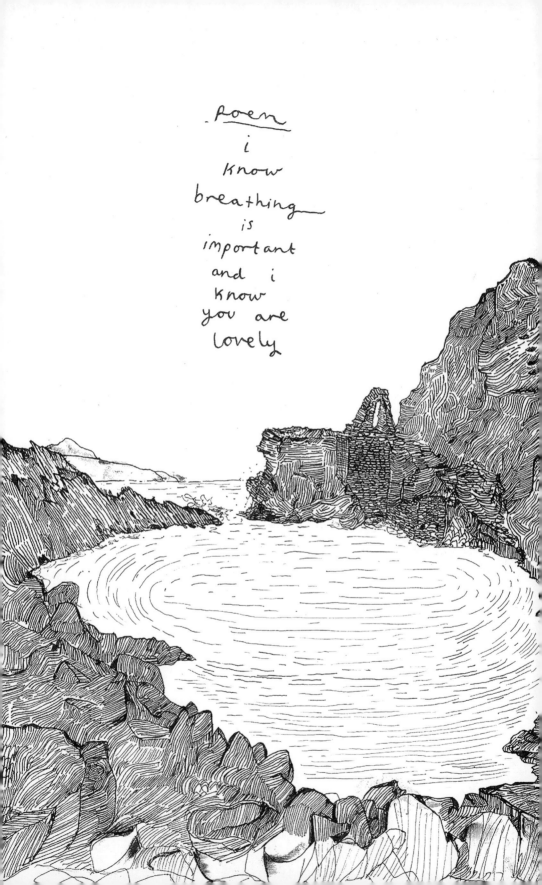

poem
i
know
breathing
is
important
and i
know
you are
lovely

POEM

I'm not a trained therapist no
I'm just polite and you
Talk a lot.

POEM

i'm going to

go for a poo

in M&S

to

celebrate

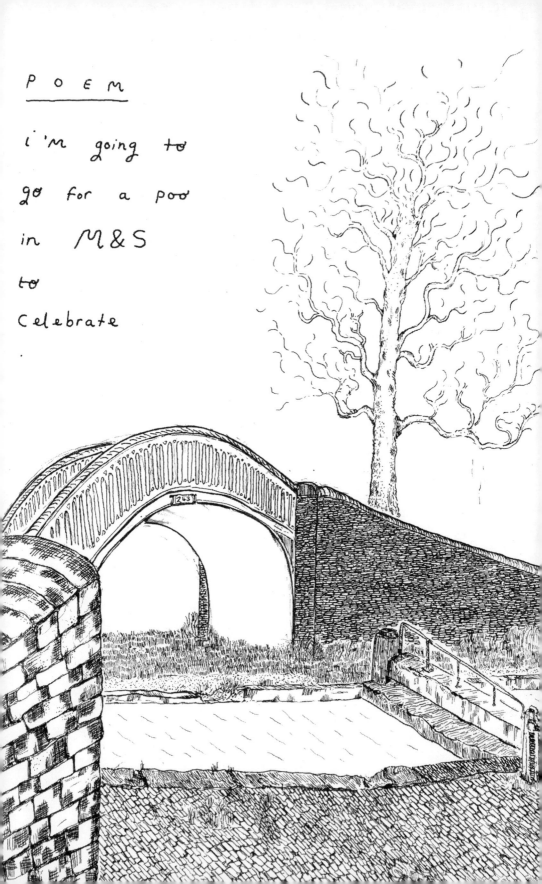

POEM

It's not a holiday
Until you've thrown
A plastic chair.

P O E M

.2.2021

even loneliness is a paradox
nowadays, i long for you
completely but also
don't
touch
me

POEM

Now is the time to be uncivil
Now is the time to eat up hope
Now is the time to stop watching films
Where everyone miraculously has really nice flats
In the centre of London even though
They are supposed to be really, really poor.

POEM

Don't panic.
Breathe.
Breathe.
You are floating
through flares
of
green

OUR WHEELBARROW

Our wheelbarrow is a Soprano,
 Listen carefully to the squeak.
Our wheelbarrow harmonises with the gulls
 And carts our sand
 And serenades the sea.
 Our wheelbarrow is a Soprano,
 How lucky are we?

WHAT COLOUR IS BRAVERY?

What colour is bravery?
I think there are ten thousand colours
That live in every square metre of the sea.
So, orange maybe? And yellow. And silver.
And teal. And mud.
And the window colour that looks out
Onto the picked up footprints of those
Who've had enough.

We have all had enough.

Bravery is the colour of the shit holes
We wish didn't define us.
Bravery is the colour of Heartsea.
Bravery is the colour of Salehorse.
Bravery is the colour of the pebbles
Stolen from the beach and used to
Separate you and me.

It's brave to be in pursuit
Of creating yourself.
It's brave to be in pursuit
Of dancing into knitted cherries.
It's brave to say I love you
And know you are never
Going to hear it back.
It's brave to vanish into energy.
It's brave to read about
The excited state of atoms
While everyone else is watching Love Island.

Bravery is the colour of Jessica.
Bravery is the colour of Shakespeare.
Bravery is the colour of Liu Xiaobo.
Bravery is the colour of the blood
That comes out when you get hurt.
Bravery is the colour of my sister,
Who still believes she is an afterthought.
Bravery is the colour of you.

Actors are brave. Brickies are brave.
Forensic psychologists are brave.
Receptionists at the merged doctors in
Wantage are brave.

Physics teachers. Mathematics teachers.
The tour guides at the Ramsgate Tunnels.
The bar staff.
The people who deliver love letters.
The DJs at the Quietus.
They are all colours
And all those colours are the colour brave.

I think there are ten thousand colours
That live in every square metre of the sea.
I think we are both superheroes
And we are here to save the world.
That's what you told me.

So then, bravery is the colour of us,
Always us.
Bravery is the colour of mess,
Always mess.
Bravery is the colour of
Eagles' wings.
Bravery is the colour of
'We still have time to change everything.'

What colour is bravery?
Bravery is the colour of age.
Bravery is the colour of
Childhood running away.
Bravery is the colour of knowing
That this is meant to be.
We are meant to be.

I think there are ten thousand colours
That live in every square metre of the sea
And I think we are meant to be.

That is the colour of bravery.

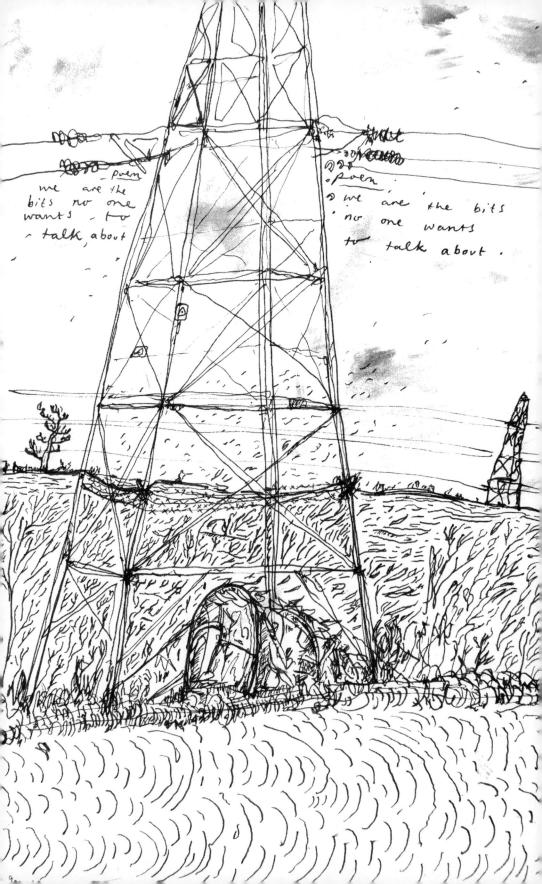

poem
we are the
bits no one
wants to
talk about

poem
we are the bits
no one wants
to talk about.

P O E M

Please seek out love
Because you are full of it
And it
makes
me
weep

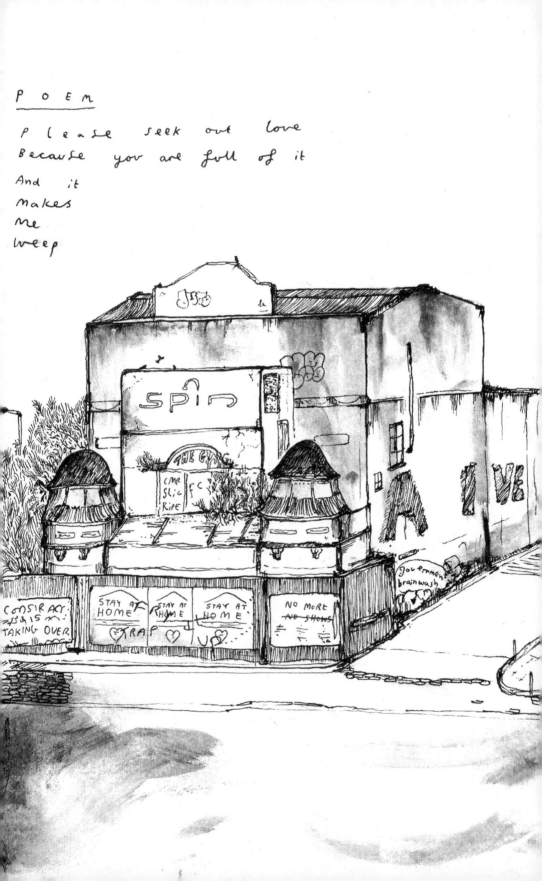

POEM

I miss talking to you
In real life.

<u>P O E M</u>

you are actually one of
the most beautiful human beings
i have ever seen .

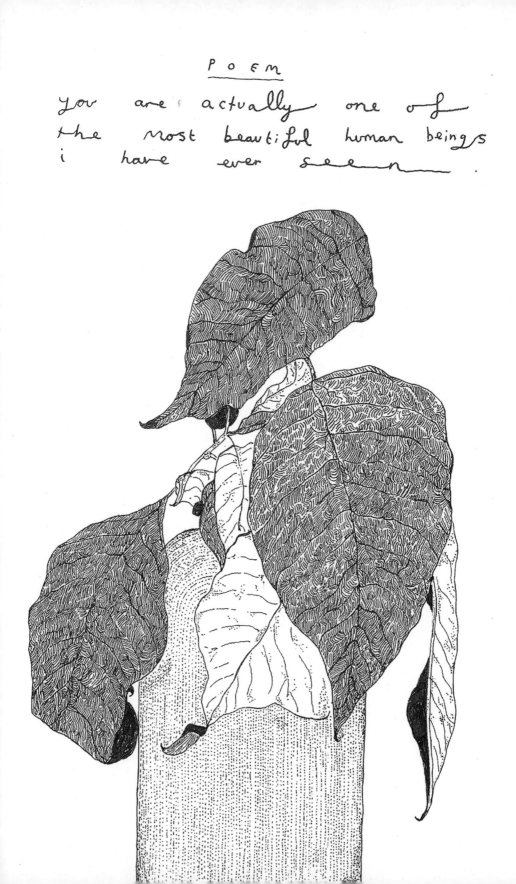

POEM

Have you ever thought
(Maybe)
We are interwoven
(Accidentally)
In the greatest love story
Ever told
(Ever in history)
And if that is the case
Have you ever thought
(Maybe)
To believe me
When I look
Down at my feet and say
'I love you'
Quietly.

POEM

i know i an honest
somewhere, so i will find
that place
and live there.

The Hanney Brooch

Look outside. We are here. Frost clings to the Hawthorn trees and the distance is invisible. You cannot see time, can you, so best to Remind yourself of its non-existence. There are icelets of hope falling from the sky, yellow skips frozen over and fields that have been ploughed for so many years we name our boroughs

after

the

dips

POEM

Nothing is constant
Step and breathe.
The sky still loves you
Step and breathe.
No way is empty
Step and breathe.
Hope is not propaganda
Step and breathe.
You are a marvellous duck
Step and breathe.
Like the old sage says:
Step and breathe
Step and breathe
Step and breathe.

POEM

we did it .
we
fucked
the
world

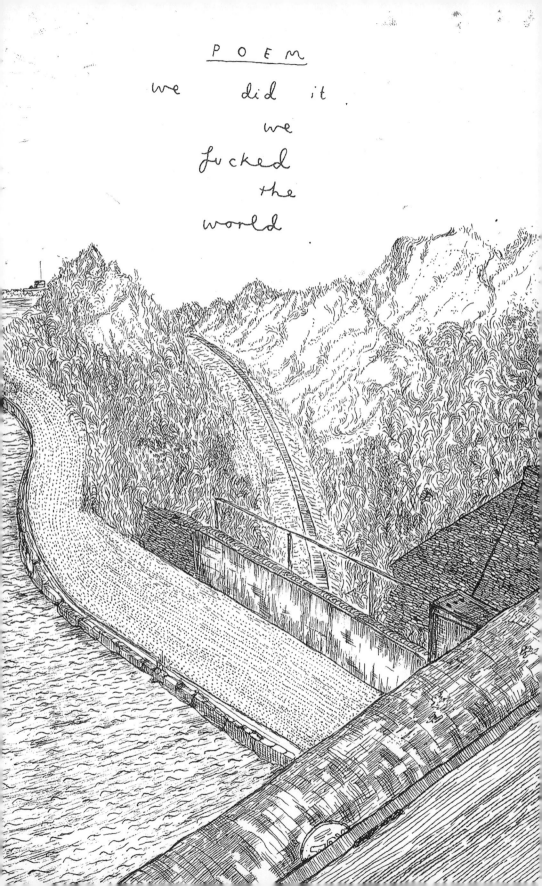

poem

i
am
ill
with

hope

.

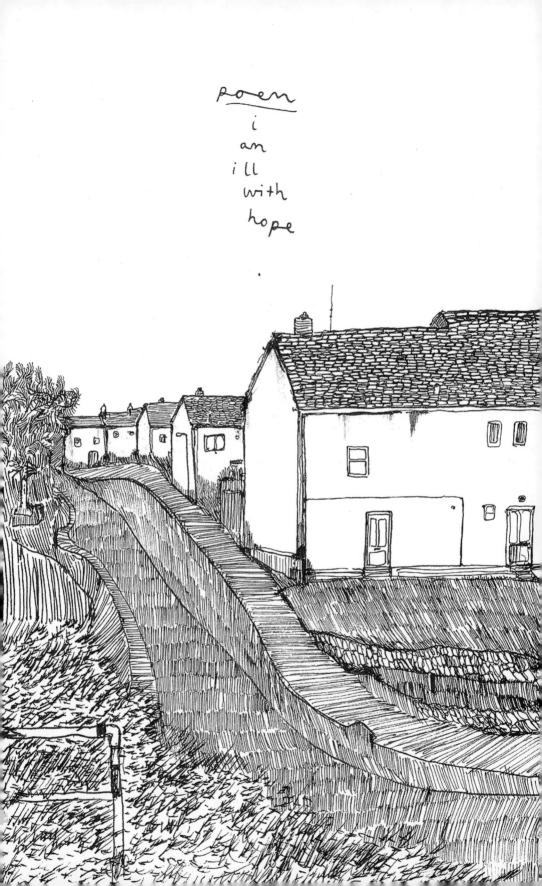

I AM ILL WITH HOPE

Dedicated to the people of Liverpool

I am ill with hope.
I am giving up lying.
I am without wax.
I am a short-eared owl searching for natterjacks.
I am using my art to make them vote.
I am ill with hope.

You don't get it
I have found
You and now
I want my whole
World to start again
Because
You are
In it.

I am a mum who is extraordinary.
I am a dog called Amalie.
I am bleaching my tongue
The colour of WKD
And dancing on the brink of
Wigan's 3ft pier
I am ill with hope.

I am the sky popping gunfire in Hightown.
I am this panic that never ends
(How fun).
I am Saul.
I am a drug addict.
Geography is important to me.
I have a tooth missing
And I drew a portrait of you in my diary.
I did it in one go and then ran away.
I am ill with hope.

I am the man who organized the NHS rally
Down by Pleasure Land
Who looks like a red squirrel
Lost on the beach.
I am the strong-willed poet
Who refuses their MBE.
I am your three-year-old niece
Playing drums
On mugs and cups and strings of bean.

I am your body
That will always reflect desperately
What you try to hide.
I am ill with hope.

I am ill with hope.
I am giving up lying.
I am without wax.
I am ashamed of my vagina.
I am Amanda
And my kids' hormones fly everywhere
Even out of their homework.
I am Judith
And I stay drunk so I don't know.
I am standing face to face with Natasha
Who has to show me a picture
Of her eyes so I can see
What they properly look like.
I am ill with hope.

You don't get it.
I have found
You and now
I want my whole
World to
Start again
Because
You are
In it.

I am picking up the Sun and putting it in the bin.
I am simple words in complicated times.
Simple words like
Fuck ecocide
Simple words like
Read about Peel Holdings
Simple words like
I wish you happy feet.
I am ill with hope.

I am Nye Bevan.
I am your children
Who are more likely to die this year.
I am worse than Margaret Thatcher.
I am Donna
And I had to choose between
Heating and food last night.

I am the ferry
That rumbles through your chest.
I am the organs of that merry-go-round
That sound a bit like screams.
I am falling into your heart
And exploding it.
'Liverpool are top of the league
And we are in a Tory majority
This is the 80s.'
A man called Ian told me that.

I am ill with hope.
I am engaged to variegated lies.
I am soz about me 100,000 times.
I am dying for you and for you again.
I am not misery porn.
I am the smile planted under
The demolition of every great port.
I am the smile planted under
The ash that has now formed harsh into a path.
I am a really good voicememoer.
I am admitting this is hard.
I am disappointment at its most conscious.
I am not an individual because
I am devastatingly in need of you.
I am standing close to you in a church.
I am standing close to you in a mosque.
I am standing close to you while we march.

I am singing

 in tears

 with you

 in the Kop.

I am singing

 in tears

 with you

 for Jon-Paul Gilhooley

 and the other ninety-six.

I am singing

 in tears

 with you

 for

 little Joe

 underneath a

 sea of scarves

I am putting out my arm to Michael
Who lives in Crosby
Who always wears fingerless gloves
And shakes a little
Who says to me seriously
He doesn't believe Transgender exists
And I am saying back to him
'Are you ok?
Michael,
Are sure you are ok?
It doesn't have to be this way you know?'
I am ill with hope.

I am ill with hope.
I am another place.
I am the play-doh outside the Tate.
I am standing at the edge of the sea
Screaming at the distance to be better
Please.
I am speaking ancient songs
In Aldi.
I am the scouse male version of
Scarlett Johansson.
I am the broken library
In Billericay.

I am the rapeseed near
Colchester that marks my map.
I am foulness,
But everywhere.

I am art where there is no art.
I am politics where there is no politics.
I am asleep in the rain.
I am alive with you completely.
I am the millions of drinks in your body.
I am the strange fields.
I am the soggy mattresses.
The cots
The fog
The faces
The bricks
The quarters
The dances
The brave
The sick
The fun
The spray paint
The gangs the containers the sinking
The anchors
The cheering
The failing

I am the kind of failing
That is never failing when
All you want is
just to listen.

You don't get it
I have found
You and now
I want my whole
World to start
Again
Because
You are
In it.

You don't get it
I have found
You and now
I want my whole
World to start
Again
Because
You are
In it.

It is favourable
To cross great rivers
So
When I wake up
I will
Be an
Empty boat.

I am giving up lying.
I am without wax.
I am ill with hope.

POEM

The Rose at
St Non's well.
She sits (floating actually)
hoping to be cured
of her infirmities, A great
wind blowing above her
that she cannot hear
from below the water.

POEM

But the naps are all i have

POEM

My hand will not kill you
My hand is not the sea
My hand is to be reached for
My hand has grip
My hand is attached to my heart
And my heart is an affectionate ship.

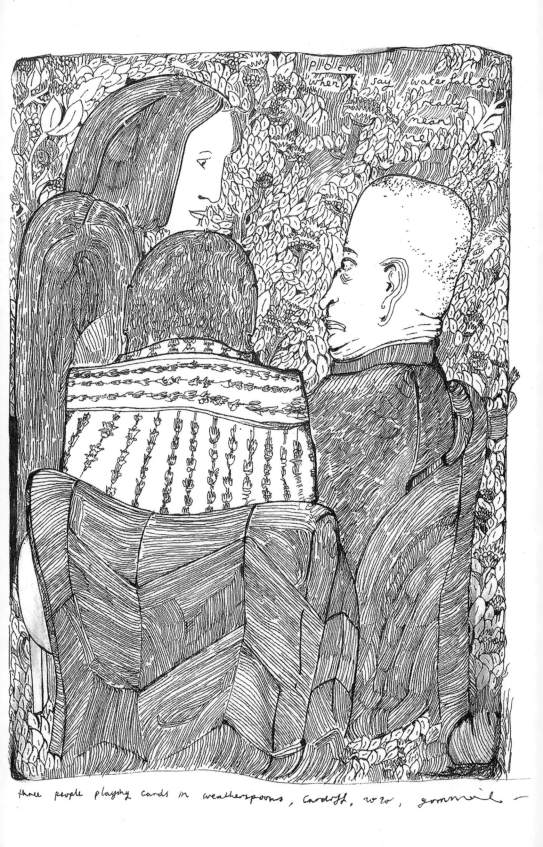

three people playing cards in weatherspoons, Cardiff, w20, jonmrich

P O E M

let's enjoy each other's
faces before time takes
them away

I PREFER THE ONES ABOUT LOVE, BEB

Dedicated to Michael from Prestatyn

I prefer the ones about love, beb.
I don't want to hear a peep
About how my life lives me.
I have three three-year-olds
My favorite sport is to sleep.
I work in Heron Foods.
My cigarette break is a
Holy fuckin' event
That takes place outside of Card Factory
With Denise.

I prefer the ones about love, beb.
The one about the underground piano?
Love that.
The one about the invisible string?
Love that.
The one that goes
I love you as surely
As the sky breathes the sea.

I prefer the ones about love, beb.
There's no use talking to me.
Talking to you is like
Dancing with a piece of bread
You're so morbid.
Dear death,

 sounds ideal.

 all the best,

 John.
(I don't even know your real name, beb
I just prefer the ones about love, beb).

I don't want to hear a peep
About how your life connects with me.
Looking up to me with your Balliol eyes.
Reaching out to me with your
Sparrow's kneecaps.
What to do around here, God only knows.
You see, I prefer the waterfalls
because they have self worth.
'You are my water
I want to do drawings on your condensation
With the tip of my finger
For a time period
That is really similar to forever.'

I prefer the ones about love, beb.

So what?
The HMS Lancaster has been beached
And misused since the 70s
But it's also a bloody good day out
If you like the zombie apocalypse
(which I do).
So what?
Fifteen-year-olds
Beating up the police in Caernarfon.
Another tent
In the doorway that someone lives in.
An abandoned tent
Underneath an electricity pylon.
All the tents
In their own class system.
The carcass of a
Collapsed caravan.
So what?
A man gently feeding his wife
a Cadbury's Chocolate Finger
As she rolls up spice under The Crown
in Glan-y-don.
So what?
You give a shit?
Is that your opinion?

I went to the homeless shelter
The day after the storm.
It was shut.
Since December
It's only been open three days a week.
Storm Jorge should invest in a calendar
For next time, shouldn't he?
I prefer the ones about love, beb.
Don't push me.

The one about the tiny pink flowers?
Love that.
The one about the longing puffin?
Love that.
That one that goes
I love you as surely as the earth glows grey.
I love you as surely as Emily makes aprons
For the local cafe that are
Brown and blue with little spoons on.
I love you as surely as I cry
When I walk away from her.
I love you as surely as I see
Machetes with decorated angel wings in Bangor.
I love you as surely as I see
Gollywogs still in the window, everywhere.
I love you as surely as
There is no money left.
I love you as surely as

This whole coast weeps
Depressed
Disheartened
In debt.

So what do we do?
Go to yoga, beb.
Grow some beautiful food, beb.
Take care of your friends, if you have any.
Make a friend of yourself, beb.
Go to Bolivia and get real with the blue stuff, beb.
And most importantly,
Be happy in your own home
And your own head,
Beb.

Imagine being fifteen again?
I never thought I wouldn't want to be
Fifteen again.
When I was fifteen there were job opportunities
– no papers –
You could travel the world
And you wouldn't die.
Now, most people wouldn't go into Rhyl
It's so dangerous.
People dying on the streets in
Another wealthy country
We ripped to pieces.

I know economists.
What wankers. Total tossers.
Growth, growth, growth.
That's not growth, it's just greed.

They can't plant a spud.
They couldn't build a fire.
They can't look after their own kids.
They have taken their pension pots.
They have taken the futures from small children.
They have taken the housing
From this generation –
And there's the thing.
There is a trillion and a half property
In this country
And the NHS is being dismantled
So the caring community will be

'We'll take back your house
And you can bury yourself
In the back garden.'

Am I wrong?
Tell me I am wrong.

I prefer the ones about love, beb.
The one about the underground piano?
Love that.

The one about the invisible string?
Love that.
The one that goes
When
The
Pressure
Comes
On
We
Turn
Into
Diamonds.

I prefer the ones about love, beb.
I prefer the ones about love.

Poem

answers
will
find
us

.

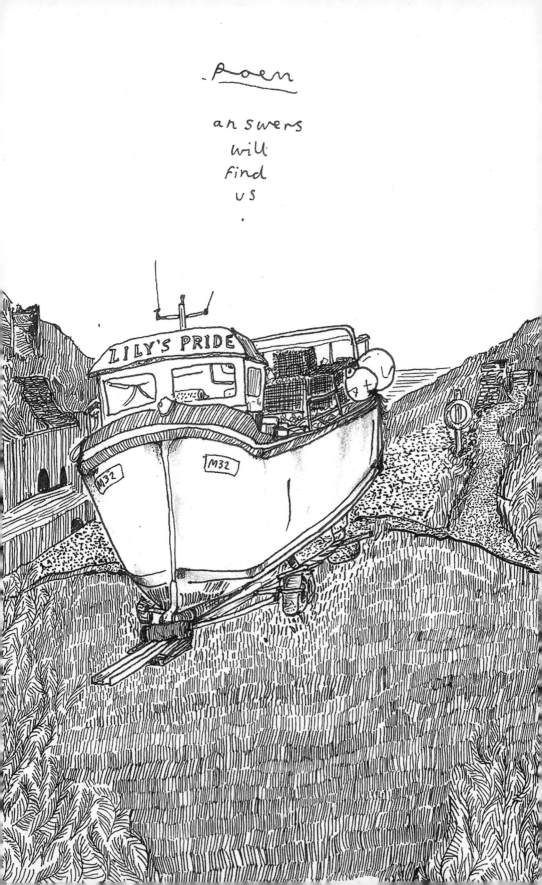

POEM

i think about you every day now. I think about you at four in the morning when i am awake and how you have probably been awake for ages already. I think about how you talk to the homeless and make everyone you meet feel young and giddy. I think about your vast and specific knowledge about this one natural subject that you teach but never impose. I think about your impact on me over the past three hundred and seventy eight days. I think about how you make me stay outside for longer. How you make me look for longer at the stream that turns into a waterfull full of self-worth. I think about your right to freedom and your right to roam. mine too. I think about you every day now.

POEM

If I do
The right thing
Today maybe
Tomorrow my life
Will
Be better.

POEM

You
Are
More
Than
Every
Poem.

i will be floating:

With wild geese and woolen jumpers. with soft smiles and miles of ancestors. i will be floating. with toil and satisfaction. with log burners and stolen settees from the harbor in Durham. Floating up mountains. floating in Joya. Floating in yellow sheds with Muslim writing on. i will be floating. Around the holy goats that stand so still they could be a mosaic. Around all the world and its presented image. i will be floating. in my own time. With a bit more work. with humility and battle. with my help to change the laws. with the responsibility of a lullaby and being familiar with myself as a pilgrim. i will be floating

POEM

So, i go, as slow, as i can,
and find, that i, still, have time.

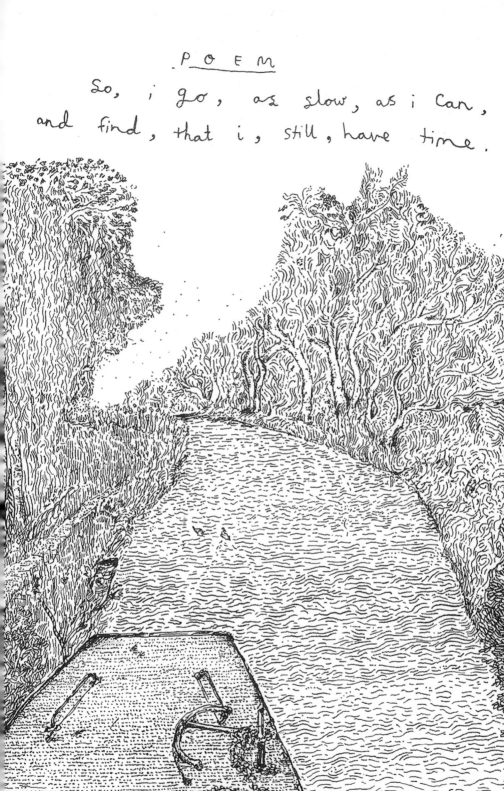

POEM

when all you care about is money
You will only ever be green with envy
when all you care about is status
You will only ever feel mighty small
when you try to skip the levels
You will only ever find the cheaters
when all you care about is how you look
You will never see how to love

The Candle

i watch until the candle
turns to plate.
my eyes blur and make
a halo around the flame.
a woman walks in and
lights a second
from the remains,
reminding me that
together
we
start
again

.

Gommie is a poet-artist that lives and works in the UK. Exhibitions include:

2019: Selected Works, Messums Gallery, London.

2019: Waving Not Drowning (Loyle Carner Album Launch), House of Vans, London.

2020: Selected Works, Messums Gallery, online exhibition due to COVID-19.

2020: Unmasked, Daniel Raphael Gallery, online group exhibition due to COVID-19.

2020: Bursting Myths, What Search And Rescue Really Feels Like, Refugee Rescue, online.

2021: Poems On Things, Daniel Raphael Gallery.

2022: Step and Breathe, Old Fire Station Gallery.

2022: Soho House Collection, ongoing.